Through the Lens of Faith

Auschwitz

HENRI LUSTIGER THALER
Curator

CARYL ENGLANDER
Photographer

DANIEL LIBESKIND
Principal Designer-Architect

Steidl

עמוד אש AMUD AISH MEMORIAL MUSEUM
THE KLEINMAN HOLOCAUST EDUCATION CENTER

Through the Lens of Faith

Henri Lustiger Thaler

Through the Lens of Faith addresses the religious belief systems that prisoners carried with them as they entered the Auschwitz concentration camp complex. Their faith-based cultural identities did not vanish in Auschwitz, nor did they determine who lived or died. Yet spiritually emotive bonds among prisoners fueled the embers of hope in the death camp, as evidenced in survivor testimonies, memoires, diaries, as well as rabbinical and other religious writings. These attachments were, for many, the central conduits for individual and collective expressions of sustenance and hope. Our intent in this exhibit is not to address theological issues, but to understand the meanings associated with faith and the phenomenon of resiliency in states of extreme assault. The intersection of faith and hope, and the instantiated ways in which it was expressed in Auschwitz, are at the very core of this exhibit. Two of our twenty-one subjects have died since we began interviewing and photographing in 2017. The eldest participant, Helena Dunicz-Niwińska, was 102 years old. More than the expressions of realism and of faith captured through the differentiated languages of photography and text in this exhibit, the exhibit is a record of the final statements of the last living survivors of Auschwitz.

Julius Meir Tauber 91 years old
I was sixteen years old. My brother and I were two out of four hundred boys waiting to be murdered. As we were marching to the gas chamber, our hands were suddenly grasped tightly from above. We were holding onto someone else's hands. Who was this? I tell you, my grandfather came down from heaven. He took me and my brother out of the death line. It is because of him that I am here today. His last words to the both of us were: "Never leave each other alone, not even for a minute. Always stay together." That's how we made it through Auschwitz.

Through the Lens of Faith was conceptually developed by Henri Lustiger Thaler of the Amud Aish Memorial Museum in Brooklyn, New York. The exhibit is as an outgrowth of our docent training program in Auschwitz, on the role of faith in the Jewish victim experience. The responses we received over the years about the training program were so enthusiastic that it inspired us to explore the subject of faith and Auschwitz in an alternate expository form, the exhibition. Stories of survival and faith, as a way to understand the experience of the victim, are insufficiently represented in Holocaust museums and memorials, survivor-testimony archives, and Holocaust scholarship in general. Within Jewish Orthodox communities, there are memorial organizations and publishers, in Israel and the United States, that specialize in documenting these stories. Survivor memoirs and other texts have become evidentiary sources about the Holocaust in religious and Orthodox communities. There are also self-published texts by rabbis who recorded faith-based dilemmas that took place during the Holocaust in prefaces to their *seforim* (learned books). These rabbinic texts address Halachic (Jewish religious law) questions

and inquiries, presenting a complex array of conundrums and dilemmas that religious Jews faced in the ghettos and camps. These texts and their approaches to historiography are directed to specific publics. Interpretations tend to situate historical events within a metaphoric and meta-historical master narrative, shaping perceptions within the communities.

Investigating faith as both an individual and a collective response during the Holocaust, allows us to consider yet new forms of meaning-making, seventy-five years after the event. In an influential statement on Auschwitz, the philosopher Giorgio Agamben explored the *muselmann* (a concentration camp slang term for starving, emaciated Jewish prisoners, resigned to their impending death) as a figurative trope. The *muselmann* though alive cannot speak and can no longer tell his story. It has become, in Holocaust prisoner symbology, a tortured allegory for the precipitous decay of meaning in the camps. However, a collective generalization of the allegorical *muselmann* is problematic. The practice of faith and its subterranean expressions in Auschwitz are wellsprings within an alternate paradigm for understanding the victim experience: a phenomenal approach that asks questions about meaning-making in the camp, with attention to their traditional sources of origin. According to the population estimates by demographers of prewar Jewish Europe, the majority of Jews and other prisoners murdered at Auschwitz-Birkenau—particularly those from the rural regions of Poland, Ukraine, Romania, Czechoslovakia, and Hungary—were predominately of faith-based backgrounds, varieties of Orthodoxy and otherwise. In spite of the Haskalah (the Jewish Enlightenment), most were still deeply immersed in the knowledge of Jewish faith-based practices, even if they themselves were not observant. Our interest is therefore to convey

stratified meanings associated with this "lost world" as a reflection of the cultural values carried into the death camp.

Baruch Gross 90 years old
I was fifteen years old when I saw Jews clearing suitcases from the cattle cars in Auschwitz. I asked them, "Where are we?" One said in Yiddish: "This is the place where they choose your destiny." I saw women separated from the men. I didn't know the meaning of it. I knew at home we *davened* [prayed] *Shacharis*, *Minchah*, and *Ma'ariv* [daily prayer services]. We were separate from the women. But what was this? They were all destined for the crematorium. I came from a town in Czechoslovakia, Humeneh. Though there were many houses of worship, every Jew in my small town was Orthodox.

When we received permission from the State Museum of Auschwitz-Birkenau to develop this exhibit, its exact placement on the premises remained an open question. Because of multiple constraints at the memorial site, we were not permitted to build an outdoor exhibit within the parameters of the former camp. If we had insisted, it could have been placed in one of the designated Blocks, where many national exhibitions are shown. We wanted maximum exposure, especially with the upcoming seventy-fifth anniversary commemoration of the liberation, in January 2020. Our sights turned to the entrance of Auschwitz 1, the arrival point for all visitors to the site. We were offered the pathway to the main entrance of the camp, a location often used by the March of the Living program, to exhibit photos of their visits to the memorial site. During the summer season, one thousand visitors per hour pass through this general area. The pathway, however, was deeply compromised from our perspective: it is the least solemn location near the site. Our anxieties heightened when we observed visitors eating and consuming soft drinks on the road to the entrance. The exhibit photographer, Caryl Englander, refused to have

her work on the pathway. We agreed. We asked the Auschwitz Museum for permission to locate the exhibit at the entrance to Birkenau, near the infamous Gate House, or as prisoners referred to it, the Gate of Death. Once again, safety regulations governing the entrance to Birkenau did not permit an outdoor exhibit. With our options, considerably narrowed, we returned to Auschwitz 1.

The spatial/visual and emotional impact of Auschwitz 1 on the visitor to the site, begs the question: how was this possible, and through what diabolical imagination? From a curatorial standpoint, a different question arises: how can images of survivors and their words speak within this space, overladen with the mnemonic omnipresence of the Nazi perpetrator? Because of this discordant and inherently ambivalent juxtaposition of perpetrator and the victim, *Through the Lens of Faith* required an ethical and aesthetic space that allowed for the interdependent copresence of two opposing master narratives. We required a location tethered to the site of destruction but with an equidistance that allowed for the projection of hope. We chose a grassy area to the left of the main pathway, surrounded by trees, with the help of the deputy director of Auschwitz, Andrzej Kacorzyk.

Through the Lens of Faith has several interwoven points of origin. The founder and president of the Amud Aish Memorial Museum, Elly Kleinman, initiated early negotiations to realize the Auschwitz docent training program and the exhibit. Further formative discussions continued with Rabbi Sholom Friedmann, director of the Amud Aish Memorial Museum. Rabbi Friedmann was involved in the conceptual planning of both engagements at Auschwitz and was an important advocate and counsel to the exhibit, up to completion. Work began on finding the artists who could interpret the complex faith dimension of our overall program.

Englander, a chairperson of the International Center of Photography in New York, was invited to be the portraitist and photo cocurator. Englander and Lustiger Thaler, chief curator of the exhibit, invited Daniel Libeskind, the architect of the Jewish Museum in Berlin, to be the exhibit designer.

Englander's Auschwitz images represent a visual passage, a pictorial osmosis of the past and present within survivor portraiture. They capture the singular reflexive splendor of lives lived, so many years after the Holocaust. The photo medium is color, suggestive of the full spectrum of light and life. The portraits are mnemonic lenses into the past of faith-based memories of Auschwitz. Her understanding of the importance of capturing these multiple sentiments remained firm and inspiring throughout our interviewing process and photo shoots. Her portraits are of twenty-one Auschwitz survivors, most of whom lost entire families in the Holocaust and many of whom now have eighty-plus great-grandchildren. This signifies the fragmented and jagged landscape of memory between unfathomable loss and the miracle of Jewish rebirth. The exact number of grandchildren and great-grandchildren in Jewish Orthodox families is not easily divulged. In the Books of Prophets, Hosea states, "The number of the Children of Israel shall be like the sand in the sea, which shall be measured nor counted." We recorded the numbers, never sure of their accuracy.

Englander's photographic work unfolded in the midst of my interviews. Each portrait embodies fragments of difficult, wistful, and hopeful memories of acts of survival. Her lens framed Yitzchok Baruch Schachter's description about how he and other prisoners in the barracks hid their praying at night from the Kapos. Esther Peterseil, resilient, forthright, with a now-settled sadness in her voice, speaks about her father's life in prewar

Bendin, Poland. Her father was a follower of the fourth Radomsker Rebbe, Rabbi Chanoch Hakohen Rabinowicz, murdered by the Nazis in the Warsaw Ghetto in 1942. Peterseil shows the Auschwitz tattoo on her forearm to Englander. Helena Dunicz-Niwińska, a Polish Catholic prisoner in the women's orchestra in Birkenau, speaks of her mother's last dying request, asking her to bring blessings to her brothers. Zofia Posmysz, a Polish Catholic, looks away from the camera as she recounts memories associated with a religious medallion gifted to her in the camp. Peter Höllenreiner, a Sinti child survivor and today a member of the Free Christian Church, speaks of the comfort of his mother's lap at the age of four in the *Zigeunerfamilienlager* (Gypsy family camp) in Auschwitz. Jewish survivor Tzipora Magda Waller smiles into Englander's camera, and when I asked her for closing words to the interview, she states emphatically: "Be kind to others. Be kind."

Englander's working process radically transformed the video interview sessions, from a pro forma genre—through the constant presence of another mediating incursion, the camera—into what seemed like a Barthesian moment of a single image with a language, a testimony of its own. But, unlike Roland Barthes, who views within the photo a cultivated resistance to language, her portraits interact and exchange understandings with the descriptive texts from the interviews. This creates a unique compendium of visual and verbal cues, an interlanguage, a phenomenal "third space" for assessing the experience and knowledge about faith, among survivors in Auschwitz. This fortuitous combination creates a productive synthesis, what W. J. T. Mitchell understood as an "imagetext." His term is a useful conceptual framework from which to view the artful core and memorial contribution of *Through the Lens of Faith*. Mitchell, in his book *Picture Theory*

(1994), states, "The imagetext re-inscribes, within the worlds of visual and verbal representation, the shifting relations of names and things, the sayable and the seeable, discourse *about* and the experience of."

The carefully curated imagetext in this exhibit articulates the particularity of each survivor experience, enabling a different motif of representation from which to listen to the sayable, as an expression of faith-based selfhood in the camp. This provides a platform for *explaining not only what was done to Jews and others but also how they responded*. The imagetext provides curatorial and viewer access into faith experiences as a separate phenomenal category and domain of understanding about survivors.

The concept developer, Lustiger Thaler, chose approximately two hundred words from each of the interviews. The first intention was to be as textually minimalist as possible, thus allowing the Barthesian language of photography to emerge. Upon lengthy discussions with Dominique Lévy, the exhibit consultant, we soon realized that the convergence of stories of faith and destruction were too layered, too expressive to be tightly edited. The didactics were extended. Englander and Lévy were intrigued with the age at which our subjects first experienced the camp. Most were children and adolescents, the youngest four years old. Their ages of entry into Auschwitz became a scarred dialect of experiential origins and emerged as a meaningful series of recurring repetitions throughout the exhibit. The twenty-one didactics commence with: "I was eleven years old," "I was ten years old," "I was fourteen years old," "I was four years old."

The exhibit is composed of images and words of eighteen Jewish survivors, referencing the spiritual numeric for life, *Chai*. (According to the medieval Kabbalah, *Chai* is the lowest emanation [closest to the physical plane] of

God.) Also included are two Polish Catholic survivors, and one Sinti, Free Christian survivor. The interview questions were structured to bracket the separate phenomena of individual and collective responses through faith-based inquiries. In the semiotics of meaning-making in Auschwitz, they are inseparable, yet distinct. They embody both personal and shareable faith narratives, such as communal prayer, donning *tefillin* (phylacteries worn by Jewish men at weekday morning prayers), and the clandestine celebration of holidays.

Ernest Gelb recounts, "On Rosh Hashanah, we were, of course, forbidden to pray, but, we did it quietly during our everyday work marches. Communicating with other Jews through prayer was important for me. We could all hope and imagine together, God willing, that next year we would be out of here." Yitzchok Baruch Schachter describes a night in the barracks: "We were eight people in one bed. When one moved, everyone had to move in the same direction to keep covered. Like this we *davened* [prayed]. No *siddur* [prayer book]. Nothing. In the cold."

Much attention has been given to the loss of faith among religious Jews during the Holocaust. As an Orthodox colleague and legal scholar Harry Reicher once remarked to me: "I am not surprised that individuals lost their faith during the Holocaust. I am moved by the fact that so many didn't." Our understandings of this time and on this issue remain anecdotal. There is empirical evidence of a robust return to Orthodox Judaism by survivors in the displaced persons camps in the American and British military zones of occupied Germany, from 1945 to 1950. Individuals in the postwar period related to faith as part of their future, the basis upon which to begin families and rebuild communities by reconnecting with cultural traditions they coveted before the Holocaust.

While marching to work, Rabbi Nissan Mangel saw a boy hanging from the gallows. "People on the march screamed, 'God, where are you?' I saw the exact same barbarity. The man could not reconcile what he saw, with a compassionate God. My father told me that fire makes things hard, or it can make them melt away. My *emunah* [faith] became stronger that day." Avraham Zelcer, on arrival in Auschwitz, asked a Jewish prisoner unloading suitcases from the cattle cars: "Where are the women and children going?" The prisoner pointed to the chimney. He understood that the only way out for everyone in the camp was through the chimney, whether today, tomorrow, or the next day. "It took me a year after the liberation to return to my faith." These qualitatively opposed responses capture the permanence and alterity of survivor faith-based experiences. Rather than definitive closures, we witnessed in the immediate postwar period a process of spiritual struggle and recontextualization, post-traumatic communal healing, the centrality of rabbinic counseling, and the return of religious marriages and the births of children, with faith once again the instructive guiding narrative for many.

Through the Lens of Faith is designed by the renowned architect Daniel Libeskind. The first iteration Libeskind created was an immersive circular and contemplative space, remarkable in its symbolic chapel *beis medrash*-like references. It was rejected by the Auschwitz museum as problematic because it appeared as a full construction project, making state and county permissions difficult to obtain. It was also perceived as overly artful for the site. The second and accepted iteration is composed of twenty-one portrait panels, with strategically positioned didactics. Libeskind instinctively understood the unique complexity of Auschwitz 1, as well as the abiding faith perspective we were intent on representing. He addressed the enduring

aesthetic and ethical challenges of the site by creating a location within the location. He conceived an alternate pathway, a spatially suggestive counterpoint to the visitor's road leading to the entrance of the memorial site. Halfway down the pathway, *Through the Lens of Faith* veers to the left, suggesting an interplay of several thinly parsed binaries: imprisonment and hope, the terror of the site of destruction and imaginary moments leading away from the camp toward the bucolic woods, toward life.

Joseph Bistritz 93 years old

I was seventeen years old when I arrived in Auschwitz. There was a *frum* [devoutly observant] fellow acting strangely every morning. I noticed him putting a blanket over his head and turning his back to me. He was hiding his *tefillin*. We spoke. I borrowed them. The next day he was on a selection list to be murdered. One Sunday morning, I put his *tefillin* on and went into a kind of trance, a utopic place far from the grim reality of the camp—ladies with carriages pushing their grandchildren, kids running around. What was this? Soon I was able to conjure up this illusion at will. That changed my life.

Libeskind's aesthetic contribution to the modularly exposed emotions of the image-text art materializes the core themes of this exhibit: faith and the survivor's voice in Auschwitz. He placed texts—gleaned and curated from testimonies—as graphic inscriptions on lightly blackened moveable glass panels, positioned directly in front of the portraits. This creates the interjacent aesthetic for meaningful exchanges between portraiture and language. The visitor opens the inscribed glass portal encountering two powerful representations, one visual, the other textual. Libeskind's exhibit design, in this regard, is a memorial edifice, which enables the pictorial and language to intersect in the hinterland of the holy within the unholy.

A Road Travelled

Caryl Englander

Three years ago, my friend and scholar/curator of Holocaust cultural history, Henri Lustiger Thaler, approached me, having seen my 2003 photography-based exhibition on Jewish Urban Poverty that I created for the Met Council of New York. Henri had just been appointed Chief Curator of the Amud Aish Memorial Museum in Brooklyn and wondered if I'd be interested in collaborating with him on a project to which he was deeply dedicated: documenting untold stories of the Holocaust and Jewish faith-based practices. Building on his interest in collective memory, he had begun interviewing Orthodox survivors whom he insisted held important stories not heard in most literature or museum exhibitions on the Holocaust. He wanted me to join him on an international journey to five countries to take portraits of survivors, with the hope of exhibiting them in Poland at the State Museum of Auschwitz-Birkenau. After Poland, we envisioned additional venues in the US and abroad.

To be honest, my first reaction was whether the world really needed another exhibition on the Holocaust with more survivor testimonies. There were so many stories already out there. But I decided to meet one individual Henri was interviewing, and to shoot their portrait. Within moments of meeting this first subject, I knew I was in the right place at the right time. I couldn't help but embrace the project, feeling an immediate and unique connection to the survivors as they recounted their stories. They were religious people who never lost their faith, even during the worst of times. I was convinced that here was an as-yet untold Holocaust narrative: the tale of those who against all odds maintained the wonder and joy of their religious beliefs.

I, too, come from a religious background, and we spoke the same language. This commonality made them feel comfortable and safe, and hence they were able to speak honestly, something they were not able to do before. I realized that their stories had not been told, and worse, they had been holding them in since the end of the war. To share, to offer their experiences to the world, is a cathartic release. The suffering of their pasts never obscured their courage—I never felt pity or thought they needed or wanted to be pitied. They all embrace a sense of joy and appreciation of life, an inner strength.

Although the circumstance of every chronicle is sadly the same, each story is unique and haunting in its own way. These people all had very religious lives before the war, full of family holidays, music, Shabbat traditions—sometimes including many generations in the same village or even the same home. Then, abruptly, that life was over. In the case of every participant, their strong relationship to their religion, their faith, played an essential role in their survival—it is a common thread that unites them. And yet, even after having experienced the atrocities of the Holocaust, they all returned to their Jewish customs, building and re-creating the community and family traditions.

Each story touched me differently. Even as they used the universal language of hope and courage, each survivor spoke in different tones, approached their faith from a different perspective. Most told me with awestruck reverence of being blessed by fortune, or of the stroke of fate that kept them alive. Some called these moments "miracles." I see another miracle, another source of encouragement and inspiration: because of their faith, courage, and sheer will to stay alive, this group of survivors now shares among them over a thousand grandchildren. Some have great-grandchildren and even great-great-grandchildren. They not only persisted in the face of death, they conquered its annihilating grasp. Because of this, for decades to come, their hope, joy, determination, and belief will live on through the communities they rebuilt from the ashes.

I thought long and hard about how I wanted to shoot and present these portraits: black and white versus color, formats to use, backgrounds to employ, and so on. The age group of our subjects was between 80 and 102, reflecting the current international demographic of Holocaust survivors. Soon it became very clear to me that I wanted to present them the way I felt and heard them, which was full of joy and vibrant and alive—each in their own setting and projecting their true, strong, positive self. I hope we've communicated through the photographs, the stories, and the extraordinary architectural design of the exhibition, the dignity, the courage, the humanity, of this remarkable group of people to whom we do honor.

First and foremost, I would like to dedicate this book to those who shared their homes, their stories, and their courage with me. My deepest and most profound gratitude goes to:

Chaya Rubin, for her courage to sing me the Yiddish song that she sang to herself in moments of doubt, the song that gave her the strength to stay alive.

Esther Peterseil, for her advocacy and strength over the years, speaking on behalf of her community to ensure that their memory never fades.

Meir Tauber, for his firm fist on the table as he uttered, "People just need to be kind."

Rabbi Greenwald, for his stories told in a measured and soft voice, and for radiating inner peace and beauty as he reminded me that even when everything else is taken away, dignity remains.

Helena Dunicz-Niwińska, for carrying within her the music that kept so many alive. Helena sadly passed away before the publication of this book.

Zofia Posmysc, for keeping her faith in Jesus Christ so close, and for holding onto the talisman that paved the way.

Lei Freidler, for her bravery beyond words in saving women's lives in the middle of the night, for doing the unimaginable and risking her own life to rescue others.

Sarah Kestenbaum, for finding the words, trusting me with her secrets, and allowing me to feel the freedom in her release.

Joe Bistritz, for helping me discover a thread of my father's history, and for sharing his profound experiences of trance and meditation, which allowed him to transport himself far from the horrors of the camps.

Magda Waller, for showing me that even the simplest object, a spoon, can become a metaphor for love, trust, and hope.

Ethel Kleinman, whose faith made it possible for so many to share a piece of the Haggadah.

Bronia Brandman, for her courageous and lifelong commitment to teaching, and for even as a young girl having the bravery to

stand up to Josef Mengele, insisting that he take her off the selection list.

Iti Landau, for the beauty and kindness that emanate from each word she speaks. Iti, in your presence, I am reminded that a mother's touch can give so much strength.

Rabbi Nissim Mangel, for reminding me of the depths of strength and resilience an 11-year-old boy can find in himself.

Baruch Gross, who passed before the publication of this book, for the way he inspired respect and unity among all those around him, and for his family, who will remember that the power of prayer never left him.

Irving Roth, for day-after-day never ceasing to tell his story, and whose tireless spirit and commitment to memory is both an inspiration and a call to duty to those who surround him.

Avraham Zelcer, for telling me that not a day goes by that he does not think about what happened to him and so many others, and who is in spite of it all so full of light and love.

Ernest Gelb, for his mental fortitude to *daven* and commit the Gemara to heart as he was being forced to march.

Ruth Solomon, for being a living example of a sister's love. Ruth, it was your commitment to keeping your sister alive, and her promise to keep you alive, which sustained you both. Neither of you ever gave up on the other.

Yitzchok Baruch Schachter, for his strength and his commitment to religion as the true path, even after having lost his brother.

Peter Höllenreiner, for his openness and willingness to share the story about the internment of his family in Auschwitz. His passion today is to bring awareness of the continued oppression, and lack of acceptance of the Romani and Sinti people, in Germany.

––––––––––––––––––

My gratitude to Henri Lustiger Thaler for trusting me to work with him. Henri, this project has enriched my life beyond what I could have ever imagined. Your wife and my dear friend, Barbara, hoped that I would put my love of photography to a meaningful cause, and after her death you provided me a path to that cause. I am grateful for the ways in which this collaboration has brought us closer, and helped us carry on her memory.

A deep thank you to Dominique Lévy for listening to me retell every story, for helping to curate the project's artistic vision, for suggesting that I work with Studio Libeskind and Avshi Weinstein, and for shepherding the book's concept and design. Avshi's moving musical performance, played with Auschwitz-related instruments, enriched the exhibit opening.

My thanks to Daniel and Nina Libeskind, who were able to translate and organize my thoughts into a profoundly concrete architectural realization of this project. Daniel and Nina, thank you for this remarkably thoughtful design and understanding of this project.

A heartfelt thanks to my dear family, who have supported and encouraged me throughout the years, and whose love gives me wings.

Three-meter-tall, vertical steel panels line up on both sides of a path that veers off the route leading to the Auschwitz Memorial and Museum. The repetitive pattern of the panels is reminiscent of the stripes from a prisoner's uniform, suggesting internment, while the exterior mirrored surfaces reflect the surrounding landscape and evoke a physical and spiritual freedom.

The faces of survivors in *Through the Lens of Faith* are framed in the metal plane and stand alone and suspended in the air. To access Caryl Englander's photographs, one has first to look through a glass panel on which the survivor's story is told as if through the glass darkly. The walkway is flanked by these planes and gaps. These portraits and their stories are witness both to the genocide, but also to the power of the human spirit.

We can't understand the millions that were murdered in the Holocaust, but we can understand one person's story. This exhibition brings the stories of the survivors into focus, while weaving their intimate accounts into the context of the camp and contemporary life.

Daniel Libeskind

Thank you to
The Koum Family Foundation

Joseph Bistritz

Romania / Jewish

I was 17 years old. There was a *frum* (religious) fellow in my barrack acting so strangely every morning. I noticed him putting a blanket over his head and turning his back to me. He was hiding his *tefillin* (phylacteries.) We spoke. I asked if I could borrow them. The next day he was taken to the gas chamber. One morning I put on his *tefillin* and went into a kind of trance, a utopic place far from the grim reality of the camp—ladies with carriages pushing their grandchildren, kids running around. What was this? Soon I was able to conjure up this illusion at will. That saved me.

Interviewed and photographed 2017, Florida, USA
93 years old, 4 children, 18 grandchildren, 17 great-grandchildren

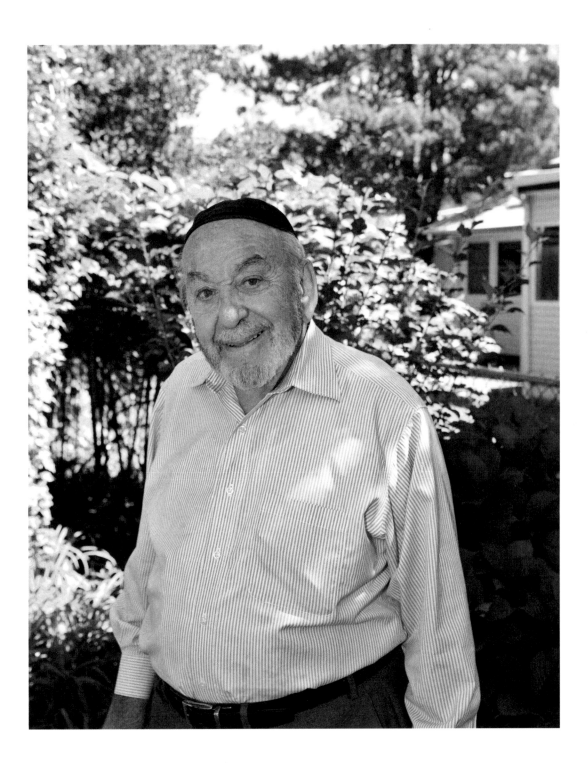

Bronia Brandman

Poland / Jewish

I was a bold 12-year-old girl. The cattle car doors opened in Auschwitz. Guards were everywhere, screaming, with guns, clubs and dogs. "Leave everything behind *Schnell*. Women and children to the left." I found myself on the right. I don't know where I found the courage, but weeks later I asked Mengele to take my number off his selection lists. I wanted to live. At that very moment, camp sirens rang out, indicating allied bombings close by. He turned ashen and ran to his car, screaming at his assistant to take my name off the death list. I was saved by allied bombing flights and Mengele's fear of death. That was a miracle.

Interviewed and photographed 2017, Brooklyn, NY, USA
88 years old, 2 children, 2 grandchildren

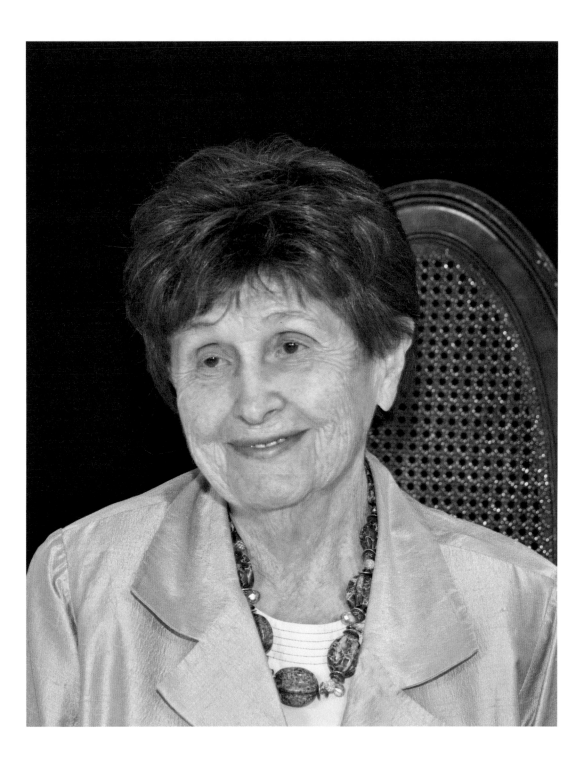

Lea Friedler

Romania / Jewish

I was 16 years old. We were deported to
Auschwitz on *Shavuos* (commemorative hol-
iday), 1944. "Hurry! Hurry! Men to the left!
Women to the right!" There was no time to
think! There was no time to say goodbye! But
your blessings were already at work Hashem.
One of the prisoners near the platform asked
my mother "Do you understand Yiddish?"
Anyu said yes. He was the first of God's mes-
sengers whom we encountered. Anyu was
holding the hands of two young orphans.
"Are these children yours?" he asked. "Let
the orphans go with the men. Stay with your
daughter." He risked his life to give us this
advice. He saved my mother and me from
certain death. That was a miracle.

Interviewed and photographed 2017, Alon Shvut,
Gush Etzion, Israel
92 years old, 3 children, 22 grandchildren, 74 great-grandchildren

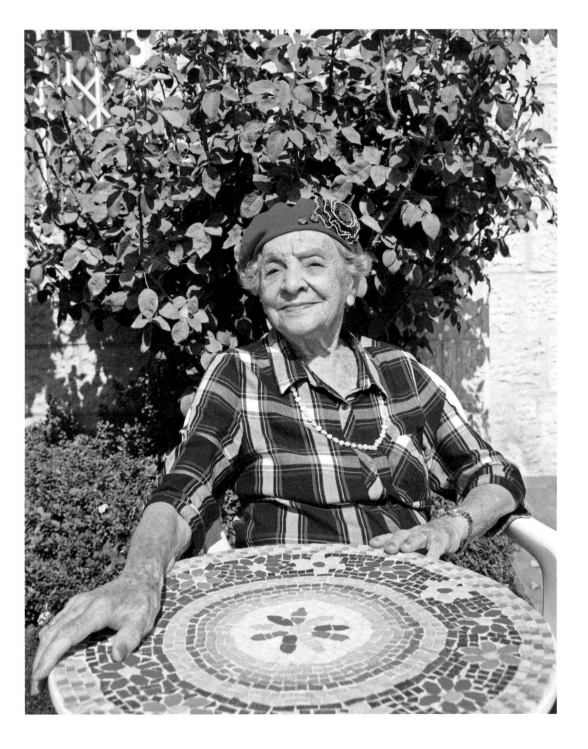

Ernest Gelb

Czechoslovakia / Jewish

I was 17 years old. I remember our daily marches to work every day in Auschwitz. Invariably there was someone who knew the morning *davening* (praying) by heart. I am not sure I felt like *davening*, but I did. The impulse for rejection was strong. Prayer, however, was a reminder of God. On Rosh Hashanah, as on all days, we were forbidden to pray. But we did it on the marches. Commiserating with other Jews through prayer was important for me. We could all hope and imagine together that, God willing, next year we would be out of there.

Interviewed and photographed 2018, West Hartford, Connecticut, USA
92 years old, 3 children, 9 grandchildren, 12 great-grandchildren

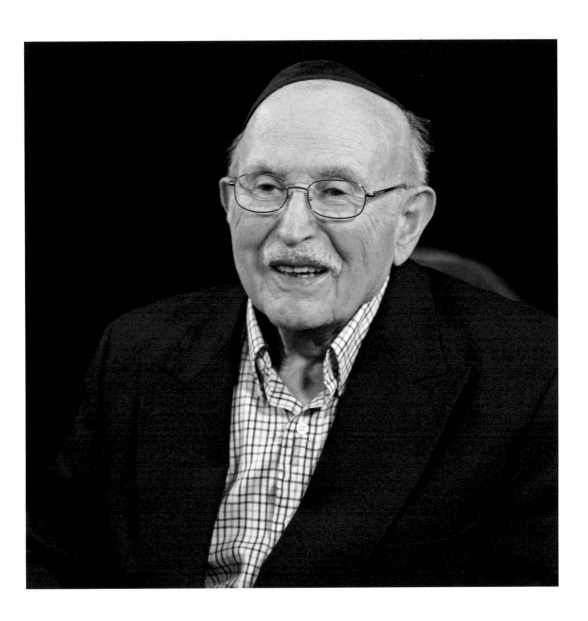

Wolf Greenwald

Hungary / Jewish

I was 14 years. It was Rosh Hashanah in Auschwitz. Rav Zvi Hersch Meisels came into barrack 21 with a *shofar* (ram's horn.) He recited the *bracha* (blessing) so many times that day and needed help conducting the service. He said to me, "You read the *brachas* and I will blow the *shofar*." I read the *bracha*. Can you imagine saying the holy blessings for the New Year to "the one above" from that place? We were all in a condemned barrack. Rabbi Meisels knew that we were selected for the gas chamber in the morning. I was ransomed out that night for 20 American dollars.

Interviewed and photographed 2017, Brooklyn, NY, USA
91 years old, 12 children, 35 grandchildren, 10 great-grandchildren

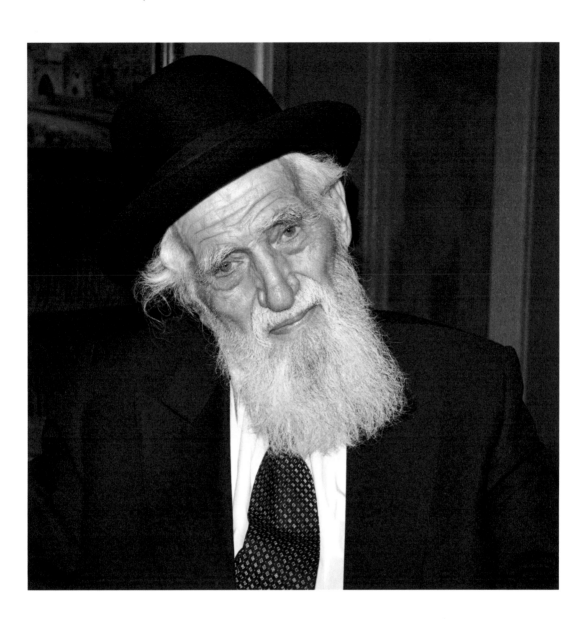

Baruch Gross

Czechoslovakia / Jewish

I was 15 years old. I saw Jews from the Kanada barracks clearing suitcases from the cattle cars in Auschwitz. I asked them, where are we? What is this place? One said in Yiddish: "This is the place where they choose your destiny." I then saw women separated from the men. I did not know the meaning of it. I knew that at home we *davened* (prayed) *Shacharis*, *Minchah* and *Ma'ariv* (daily prayer services) and we were separate from the women. But what was this? I soon understood that they were all destined for the crematorium.

Interviewed and photographed 2018, Flushing, NY, USA
90 years old, 2 children, 4 grandchildren

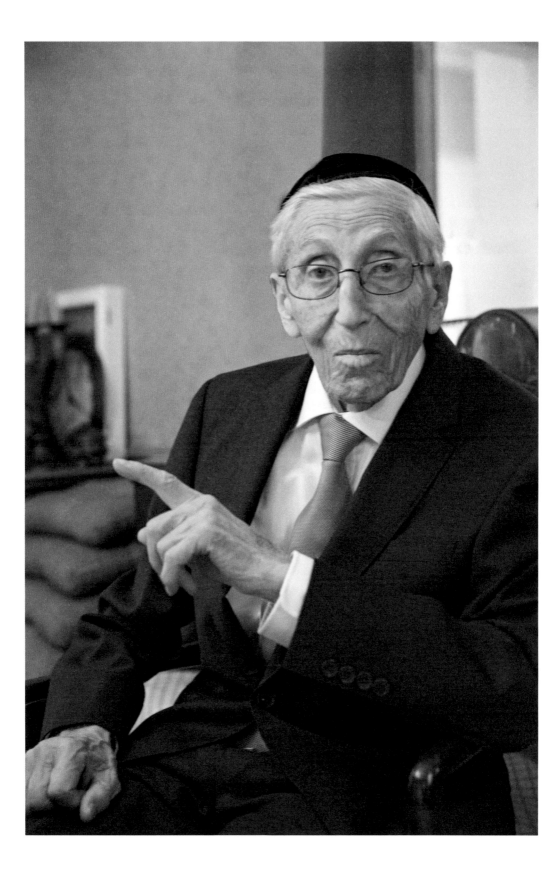

Sara Kestenbaum

Romania / Jewish

I was 13 years old, a protected child from a religious home. My father was a teacher in the Vizhnitz Yeshiva in Romania. When the train doors opened in Auschwitz, we saw German soldiers with bayonets, barking dogs, then the selection, the shaving, the prison clothes. We were marched to Barrack 14. I was so scared. I saw a young girl die from fright that day. I would have private conversations with God. I would cry. I would tell God that I was suffering. I never questioned. For me, faith was hope. I prayed that one day I would marry a religious man and have observant children.

Interviewed and photographed 2017, Florida, USA
89 years old, 3 children, 9 grandchildren, 13 great-grandchildren

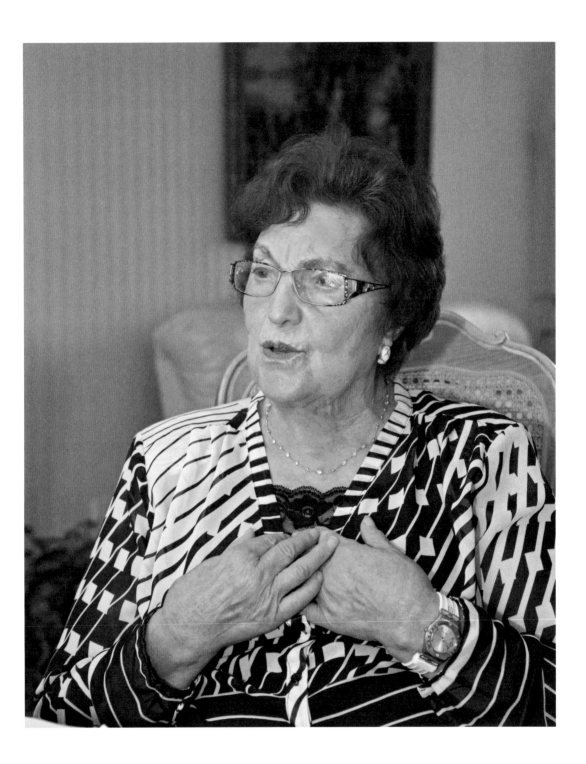

Ethel Kleinman

Hungary / Jewish

I was 20 years old. We left the cattle cars in the middle of the night. After the selection, we were taken to C Lager. At every *Appell* (roll call) there were less and less people. We were about 500 women, on one side of the electric fence, and 500 men on the other. Many of the men died during this time. We were stronger than them. Whatever we had, small morsels of bread, a potato, we threw over the fence. The men threw over small rolled-up papers every few hours. This was just before *Pesach*. It was the *Hagaddah* (the Exodus story). We pieced it together to commemorate the holiday.

Interviewed and photographed 2018, Brooklyn, NY, USA
95 years old, 3 children, 27 grandchildren, 49 great-grandchildren, 3 great-great-grandchildren

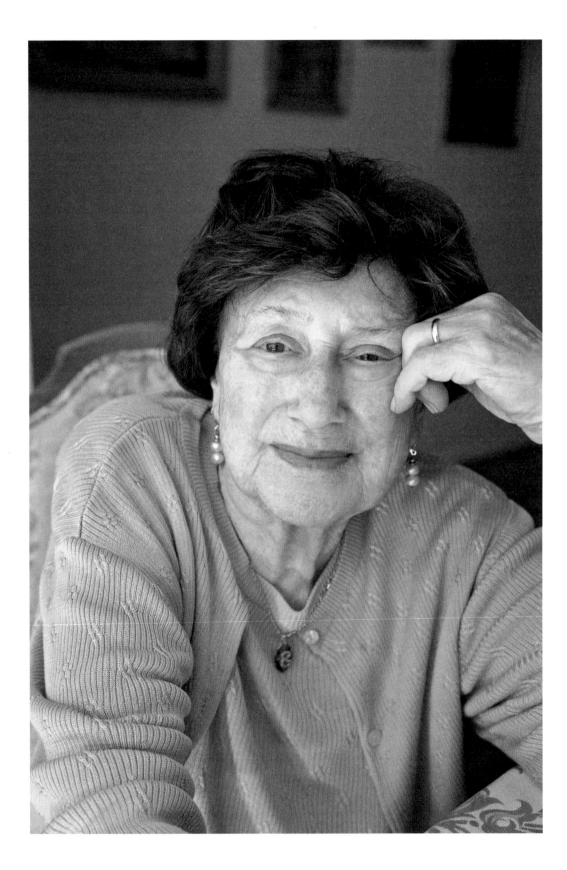

Itel Brettler Landau

Romania / Jewish

I was 16 years old. I was in B Lager. We were cold and hungry all the time. One day we marched and marched, endlessly it seemed. I didn't care about anything, least of all my own life. Suddenly I saw groups of women splitting stones. Someone called out, "Are there people from Debrecin amongst you?" It was my sister's voice. I shouted out loud, "I'm here, I'm here, God I'm here". She replied, "Mommy is here." I heard that, and I wanted to live if only to be with them. I don't know what I would have done without my mother. She always told me, "Don't forget who you are child."

Interviewed and photographed 2017, Brooklyn, NY, USA
91 years old, 3 children, 18 grandchildren, 20 great-grandchildren

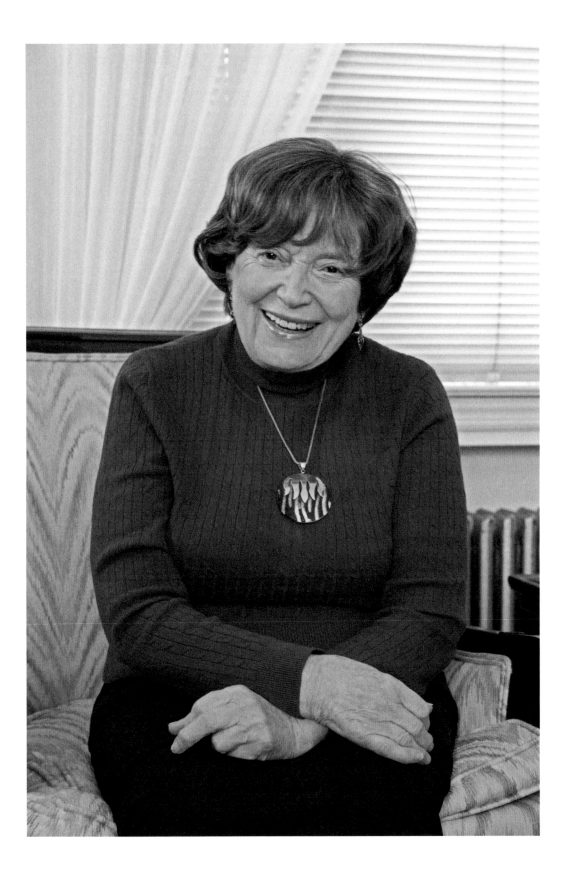

Rabbi Nissan Mangel

Czechoslovakia / Jewish

I was 11 years old. The fires of Auschwitz made some people lose their faith. One morning, I was marching with others in the camp. A man in the group saw a Jewish boy a *yingele*, dead, hanging from the gallows. He screamed: "Where are you God". Another man responded: "You know where God is? He is on the gallows with the boy. That's where he is." I saw the exact same barbarity. The man could not reconcile what he saw with a compassionate God. My father taught me that fire makes things hard, or it can make them melt. My *emunah* (faith) became stronger that day.

Interviewed and photographed 2018, Brooklyn, NY, USA
85 years old, 6 children, 23 grandchildren, 9 great-grandchildren

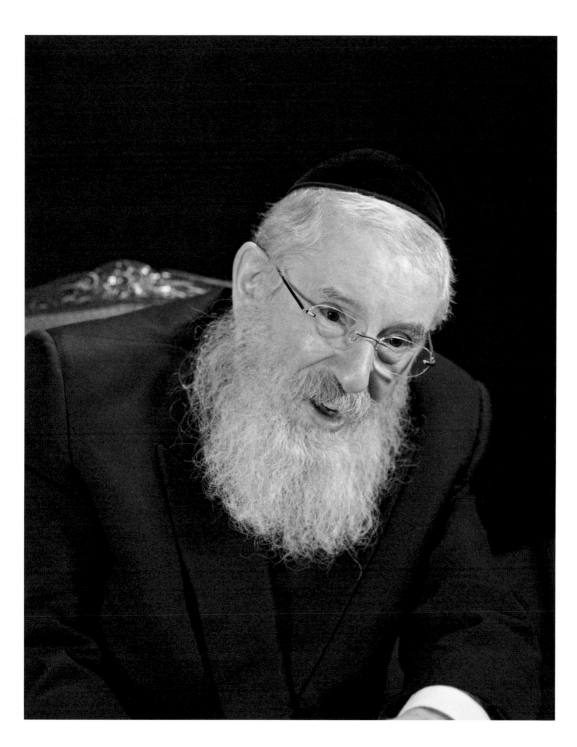

Esther Peterseil

Poland / Jewish

I was 15 years old. I prayed to God in the selection line to keep my parents alive. I believed I could not survive without them. Upon entry, men and women were separated, the young and old too. I ran quickly to be with my mother. She pushed me back firmly. Her last words were: "Take care of your sister, so she will survive. Marry a religious man. God will save you, and you will tell the world what happened to us." My mother said I had the courage to survive Auschwitz and must do so. Those words kept me alive.

Interviewed and photographed 2017, Manhattan, NY, USA
94 years old, 2 children, 12 grandchildren, 31 great-grandchildren

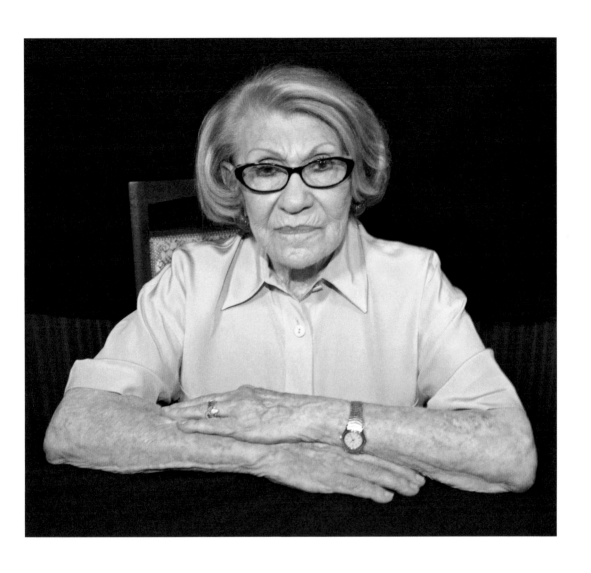

Irving Roth

Czechoslovakia / Jewish

I was 14 years. It was *Erev Yom Kippur*. I was hungry, frightened. I couldn't eat my piece of bread. I could not drink the coffee. Looking back, as a religious man, I ask myself today how did I live through this? I decided that my quarrel was not with God, but with man. It was man that created the gas chamber. Not God. In spite of all that the Nazis took from me, I made choices in the midst of this meaningless terror. I made decisions about how I would conduct myself. Faith was the only thing left. I took great comfort in that.

Interviewed and photographed 2018, Manhasset, NY, USA
90 years old, 2 children, 4 grandchildren, 2 great-grandchildren

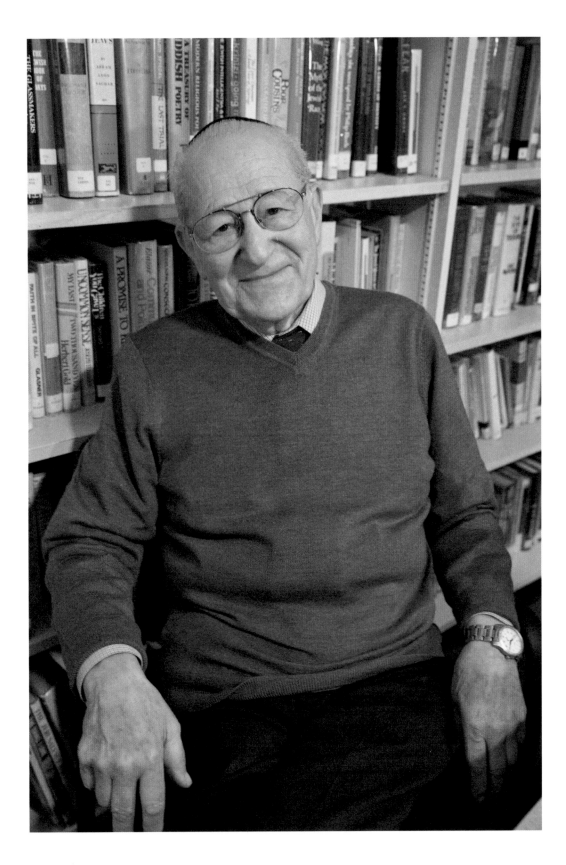

Chaya Rubin

Romania / Jewish

I was 18 years old. The train stopped on the night before *Shavuos*. Jewish boys came and took us off the train. One said, "See those fires? That is where they are taking you. Don't take any children, or you will all be killed with them." My little sister Ruchala cried, "I want to go with Suri and Chaya. I want to live." Mengele pushed her away. She knew where she was going. My mother looked at me. I never saw my father again. We sang a song of hope, every night, that my aunt wrote. "Oh Jews, we have troubles, but when *Mashiach* (Messiah) comes our prayers will have been accepted."

Interviewed and photographed 2018, Brooklyn, NY, USA
93 years old, 3 children, 12 grandchildren, 40 great-grandchildren

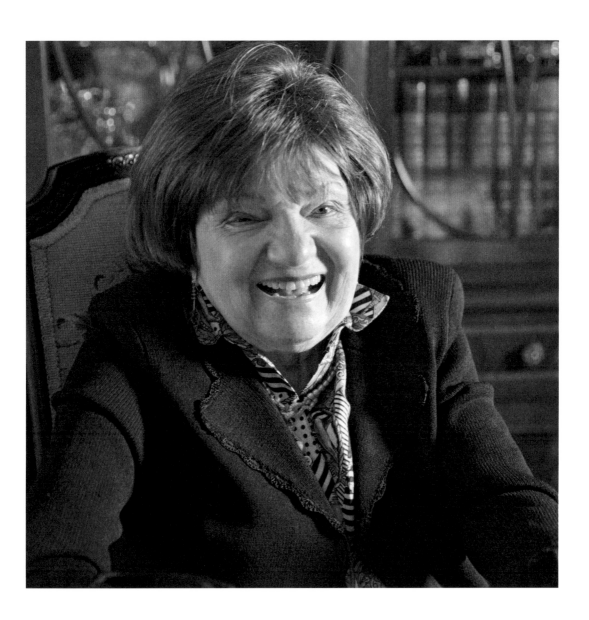

Ruth Salamon

Czechoslovakia / Jewish

I was 17 years old. My older sister and I were always together in Auschwitz. I remember the first time we received food in the camp. Could we eat it? I came from a *frum* (religious) home. The *Blockalteste* said "Eat it if you want to live." My sister and I shared everything. We walked everywhere together, hand in hand. She was my sister, my mother, my best friend. We prayed when we went to sleep. We were so close. I made sure with all my strength that she would live. I knew if she died, I would die.

Interviewed and photographed 2018, Brooklyn, NY, USA
92 years old, 2 children, 10 grandchildren, 6 great-grandchildren

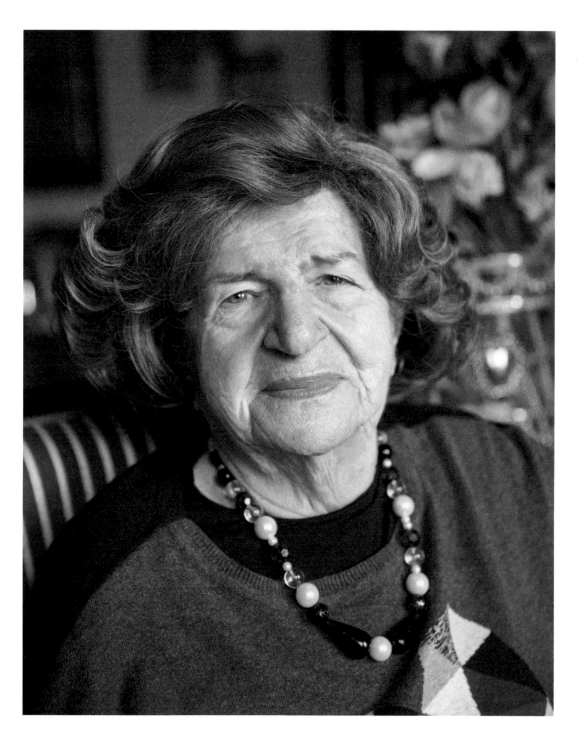

Yitzchok Baruch Schachter

Poland / Jewish

I was 17 years old. We were taken to Buna, Monowitz, a working sub-camp of Auschwitz. My brother became ill and was sent to the notorious camp hospital. I was also ill and placed in the hospital. There was a selection soon thereafter. My brother was taken to be killed. I use that selection date—the day he was removed from his bed—as his *yahrzeit* (anniversary of a death) day. At night, in the barracks, we were 8 people in one bed. When one moved, everyone had to move in the same direction to keep covered. Like this we *davened* (prayed). No siddur, Nothing. In the cold.

Interviewed and photographed 2017, Brooklyn, NY, USA
96 years old, 3 children, 16 grandchildren, 90 great-grandchildren, 9 great-great-grandchildren

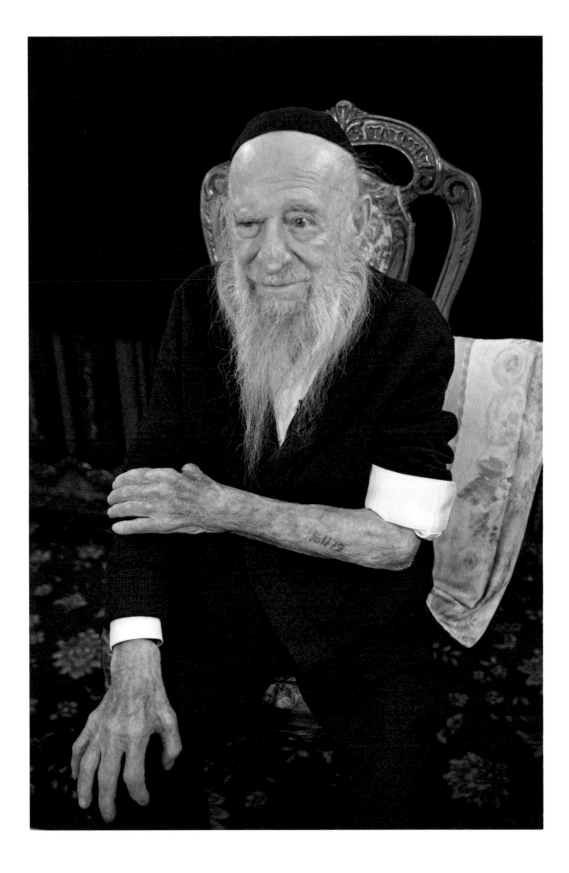

Julius Meir Tauber

Romania / Jewish

I was 16 years old. My brother and I were 2 out of 400 boys waiting to be murdered. All of a sudden, as we were marching to the gas chamber, our hands were grasped ever so tightly from above. We were holding onto someone else's hands. Who was this? I tell you my grandfather came down from heaven. He took me and my brother out of the death line. It is because of him that I am here today. His last words to both of us were: "Never leave each other alone, not for a minute. Always stay together." That's how we went through Auschwitz.

Interviewed and photographed 2017, Brooklyn, NY, USA
91 years old, 3 children, 19 grandchildren, 80 great-grandchildren

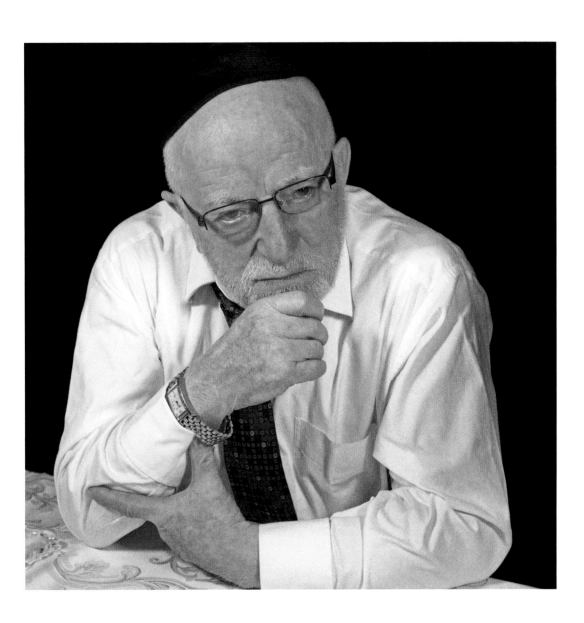

Tzipora Magda Waller

Hungary / Jewish

I was 18 years. During the selection in Auschwitz, I held onto my aunt's child. Mengele motioned me to the left. I did not understand. He screamed at me "Is that child yours? I said "No." He took Avrumy from me and pushed me to the right. I didn't know what it meant then. We believed Hashem was going to help us. But it didn't work. I was the first born, and the only one that survived. What I learned from my experience in Auschwitz is to believe in kindness. Be good to the people around you.

Interviewed and photographed 2018, Toronto, Canada
92 years old, 3 children, 16 grandchildren,
32 great-grandchildren, 3 great-great-grandchildren

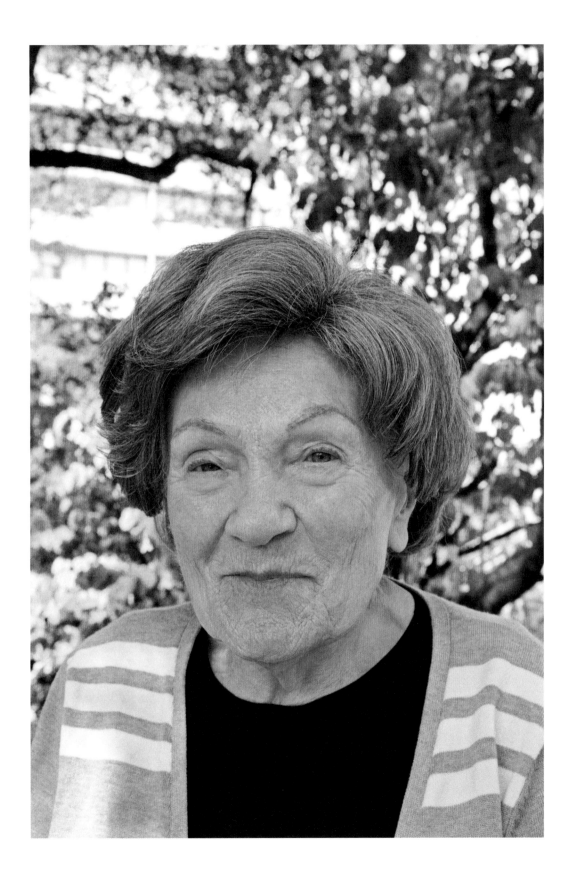

Avraham Zelcer

Czechoslovakia / Jewish

I was 16 years old. The train stopped in Auschwitz on the morning of *Shavuos* (a commemorative holiday). We thanked God we arrived. The horrors of our transport from Czechoslovakia were beyond words. So many people suffered and died. We didn't know what was waiting for us. Women and children to the left. I went to the right. I asked someone, "Where are the women and children?" He pointed to a tall chimney "They went out through there." The only way out of Auschwitz was through the chimney: today, tomorrow, or the next day. It took me a year after liberation to return to my faith.

Interviewed and photographed 2017, Queens, NY, USA
91 years old, 2 children, 8 grandchildren, 14 great-grandchildren

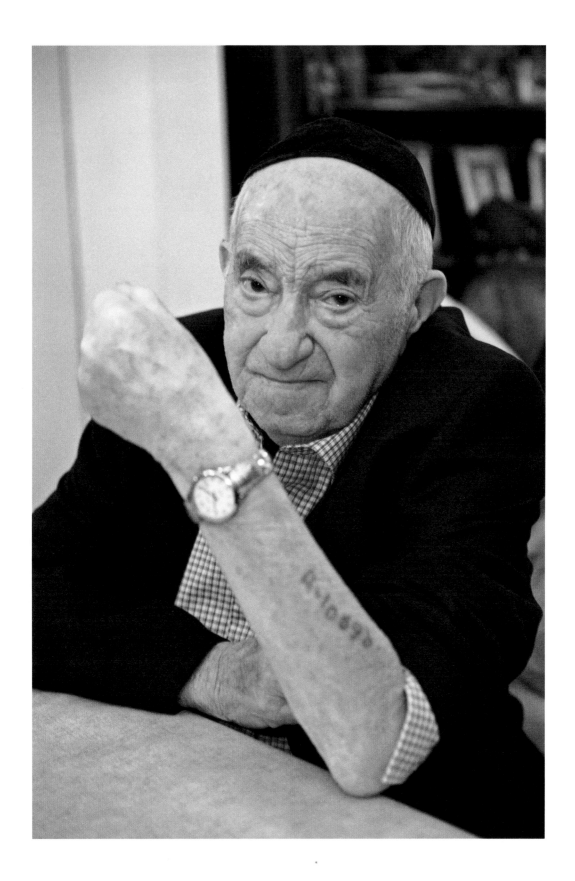

Helena Dunicz-Niwińska

Poland / Catholic

I was 25 years old. I went to Holy Mass every week with my family, before my cruel imprisonment in Auschwitz. Due to my musical background, I was assigned to play in the prison orchestra. My mother and I were in Birkenau together. She was very sick and lay untreated in the hospital barrack for four weeks. She knew she was dying. She turned to me and said: "Listen to me child, give my blessings to the boys, your brothers." My mother had faith, and it gave her power and divine protection, if not here, then in the next world.

Interviewed and photographed 2017, Krakow, Poland
102 years old (†), married, no children

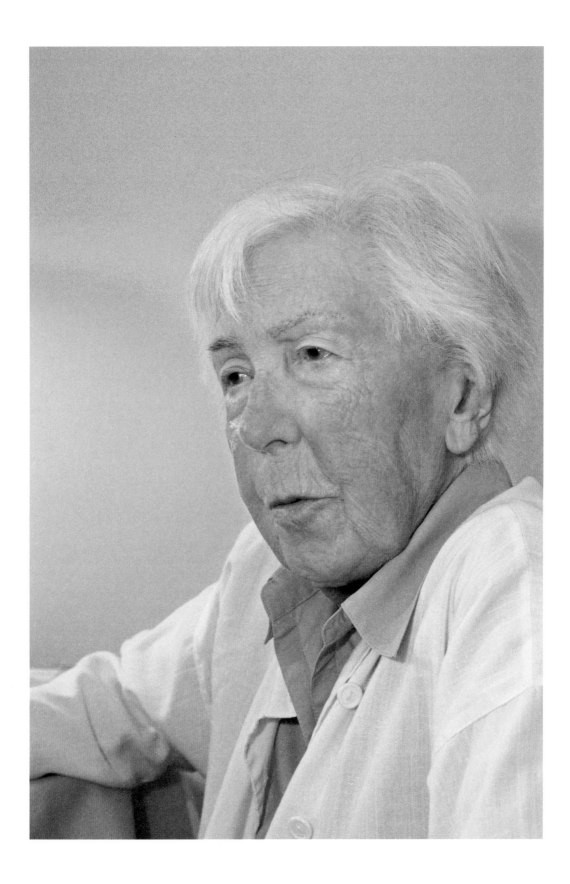

Zofia Posmysz

Poland / Catholic

I was 17 years old when I met Tadeusz Paolone-Lisowski in Birkenau. The last time I saw him, he asked me: "Do you believe in God? Because, as you know many people think that if something like Auschwitz is possible…" He didn't finish. I remembered my mother's words at that moment: "If there is evil in the world, it comes from Satan, not God." Tadeusz said, "On the pages of the account book is a small metal object for you, a medallion. Take it as a souvenir of me. May it protect you. Look after it, and if God lets you, take it to freedom."

Interviewed and photographed 2017, Warsaw, Poland
96 years old, married, no children

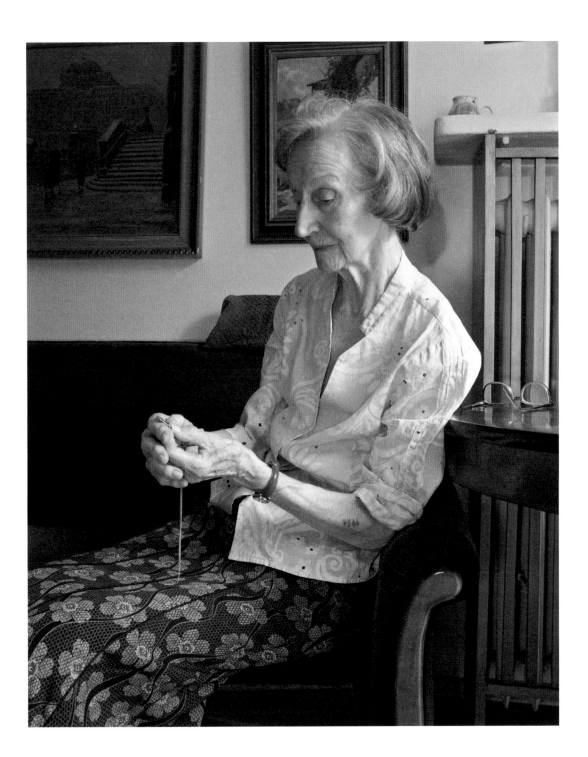

Peter Höllenreiner

Germany / Sinti Free Christian

I was 4 years old. I remember sleeping on my mother's knees. I felt breadcrumbs under my cheek. I felt safe. My father was brutally punished for giving a Jewish woman a potato. She prayed for him.

Interviewed and photographed 2019, Munich, Germany
80 years old, 4 children, 8 grandchildren, 2 great-grandchildren

They let us in through the gates,
*They let us out through the chimneys.**
Roses heaped where there were no graves.

A man remembered being a child here,
hungry, limp, on his mother's knees.
A woman remembered her godmother,
her godmother's husband, their five little girls,
who all *went up in smoke.*

In the hell of Auschwitz where real devils
lived in human skin.
We walked out under a scorching sun.

In the evening, in the garden of the *Tsiganaria,*
I danced with a man who tried to tell me,
in halting English, his father's life:
a Rom who'd served in the German army,
denounced by his landlord—*Who be you?*—

He was sent to Auschwitz, nearly starved;
came home alive, but sick and thin—
so thin, he died in months.

His plump son twirled me and kissed my hand.
God please you, he said to me, and smiled.
The moon, rose-gold above the trees.
We're here, just look at us.
God, please.

*Gypsy Song

Cecilia Woloch
Tsigan
The Gypsy Poem

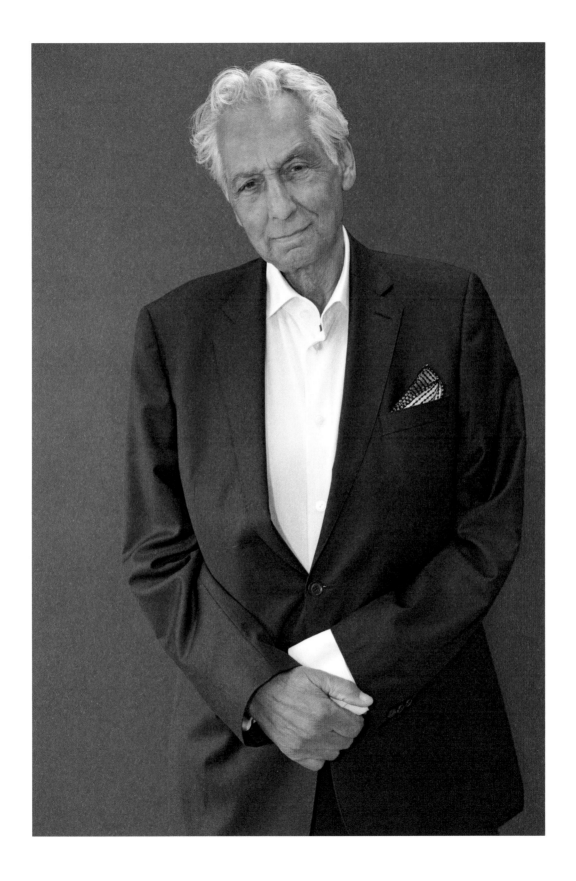

Acknowledgements

We thank The Koum Family Foundation for their philanthropic generosity. Their support of this project has been critical to its success.

We thank Founder and President Elly Kleinman and Director Rabbi Sholom Friedmann of the Amud Aish Memorial Museum in Brooklyn, New York, for their support and encouragement.

Our sincere thanks to the deputy director of the State Museum of Auschwitz-Birkenau, Andrzej Kacorsyk, for trusting this project, and for understanding its relevance and importance.

We thank with great gratitude, Johan van Lierop and Stefan Blach of Studio Libeskind for their masterful stewardship of the project.

We thank our architectural and building colleagues in Poland at Ankora, V!bes, and Grand, particularly Wojtek Kasinowicz and Joanna Lorch, for their dedication. We thank Reijnders Graveer & Lasertechniek for their skillful work on the photographs.

Thank you to Carol Dragon who looked at each and every photo, at least 300 a person. Carol helped me edit, correct and print every portrait. Her input was invaluable.

Our thanks to Benni Marvin and Yael Peri for sharing their contacts within the survivor community with us, and their filming expertise throughout the many interviews.

Thank you Piotr Jakoweńko for excellent graphic work and Katarzyna Gucio for her skillful English to Polish translations.

We thank Cecilia Woloch for permission to use her very moving poem, which references her first meeting with Peter Höllenreiner some years ago. And thank you to Joanna Talewicz-Kwiatkowska for introducing us to Peter.

Our thanks to Gerhard Steidl for publishing this book, to Gerhard and Paloma Tarrío Alves for designing it, and to Monte Packham for his meticulous editing.

Caryl Englander and Henri Lustiger Thaler